No End in Sight
Where Are the Ends of the Line?

A Collection of Clever One Line Drawings

Copyright © Tenley Wallace 2020 (Christchurch, New Zealand)

Published by Tenley Wallace

Contact: tenleyart@gmail.com

The drawings contained in this book are the property of Tenley Wallace who retains all rights to her drawings. The drawings may not be reproduced in any manner without her permission.

No part of this publication may be reproduced, stored in or introduced into a database and retrieval system or transmitted in any form or any means (electronic, mechanical, photocopying, recording or otherwise) without the prior written permission of the artist and author.

No End in Sight Where Are the Ends of the Line?

First Edition, December 2020

ISBN 978-0-473-55827-7 (Kindle - Amazon)

ISBN 978-0-473-55955-7 (Softcover - POD Amazon)

This book contains a collection of original drawings by Tenley Wallace.

Each piece is hand drawn and made of a single, continuous line that does not cross over itself.

Each drawing has two ends that are distinct ends though not always easy to find. Can you find the two ends in each of the drawings?

Follow the line to see where it goes and how the drawing is constructed. Exercise your eyes by following the line.

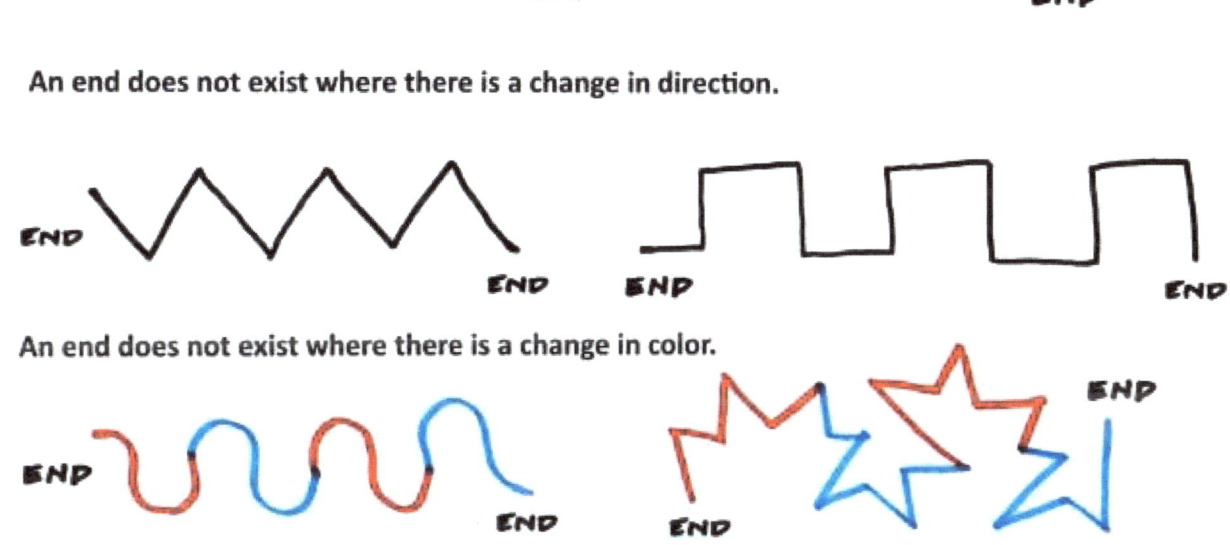

Enjoy following the path and finding the ends in each of the drawings! Happy hunting!

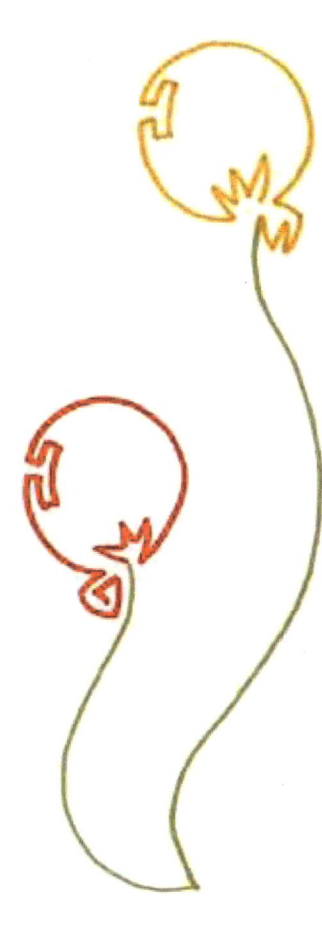
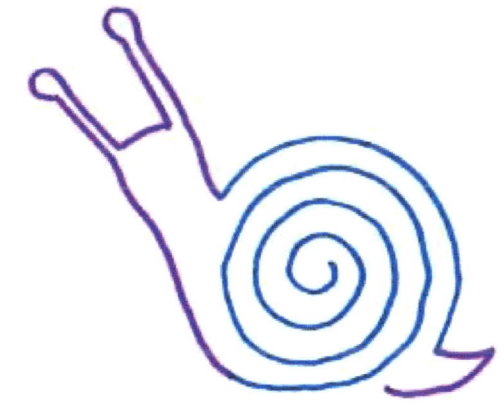

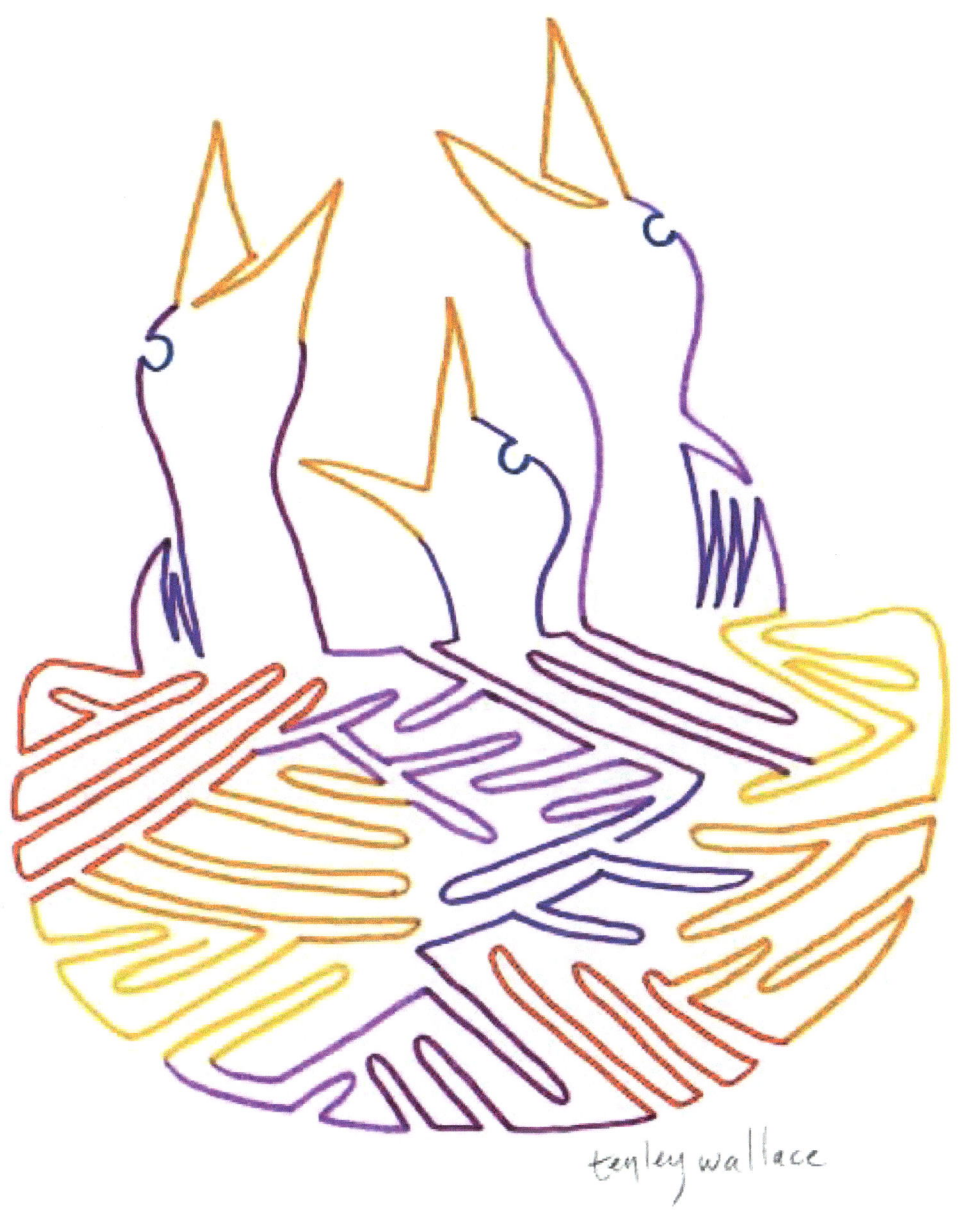

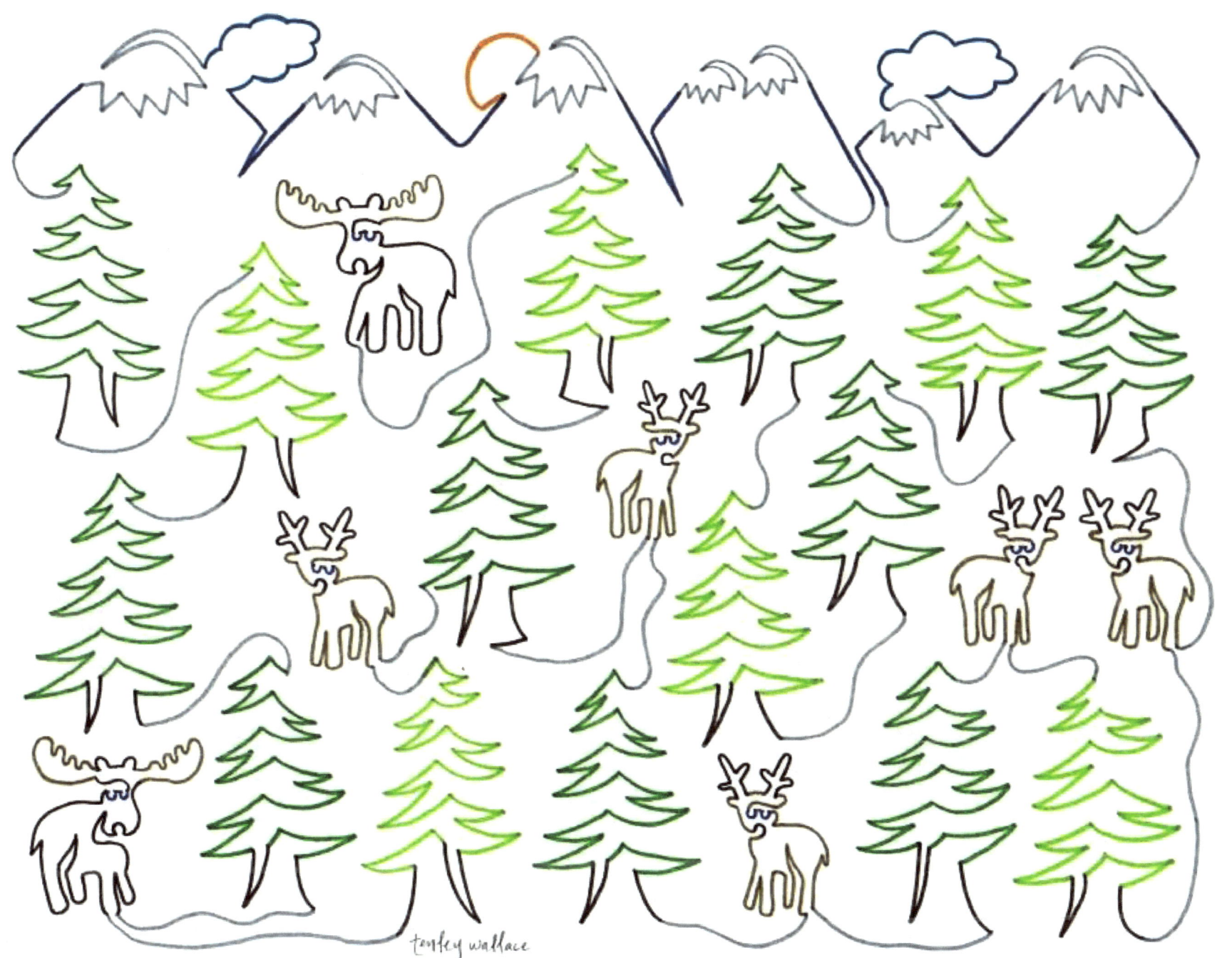

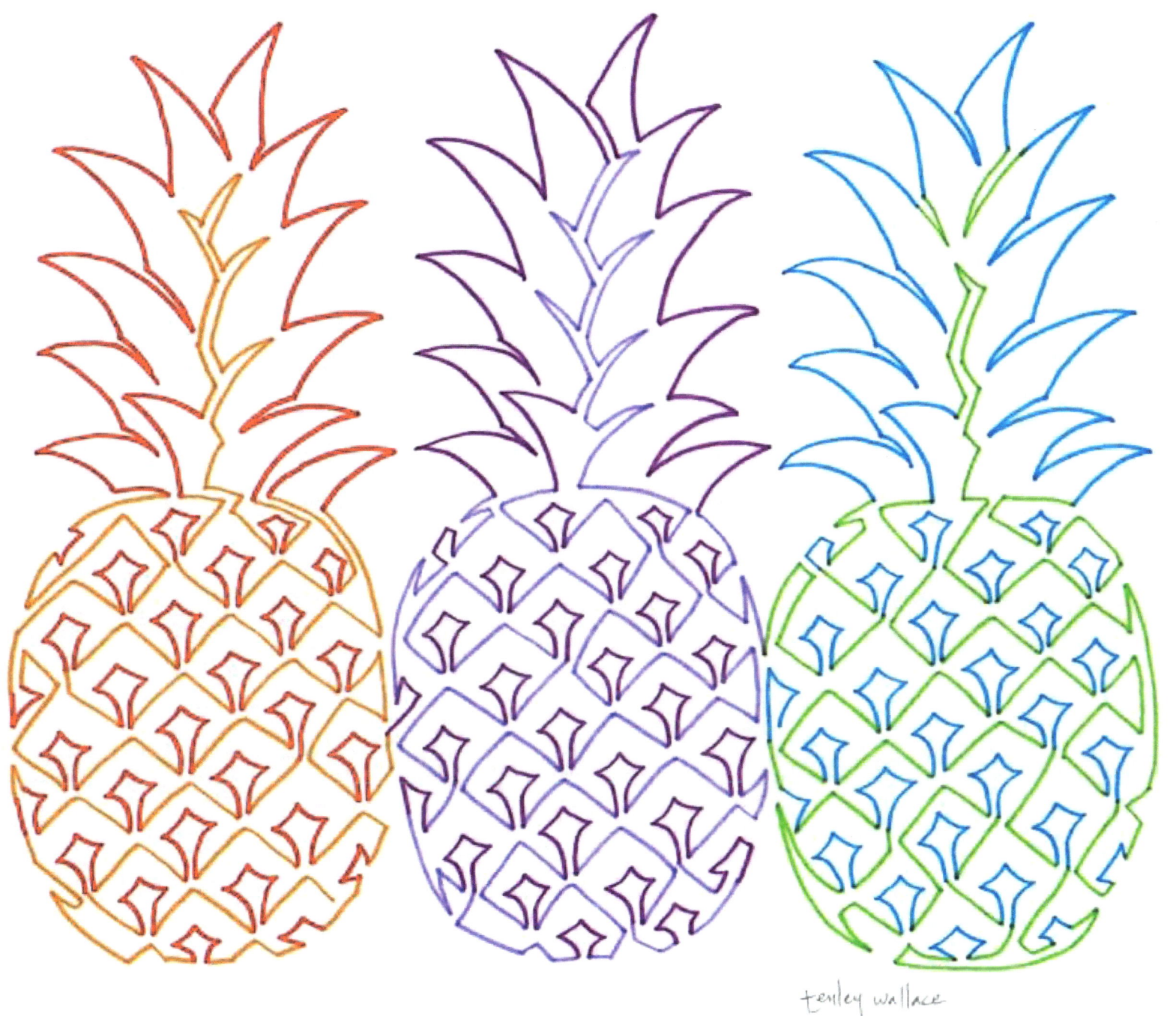

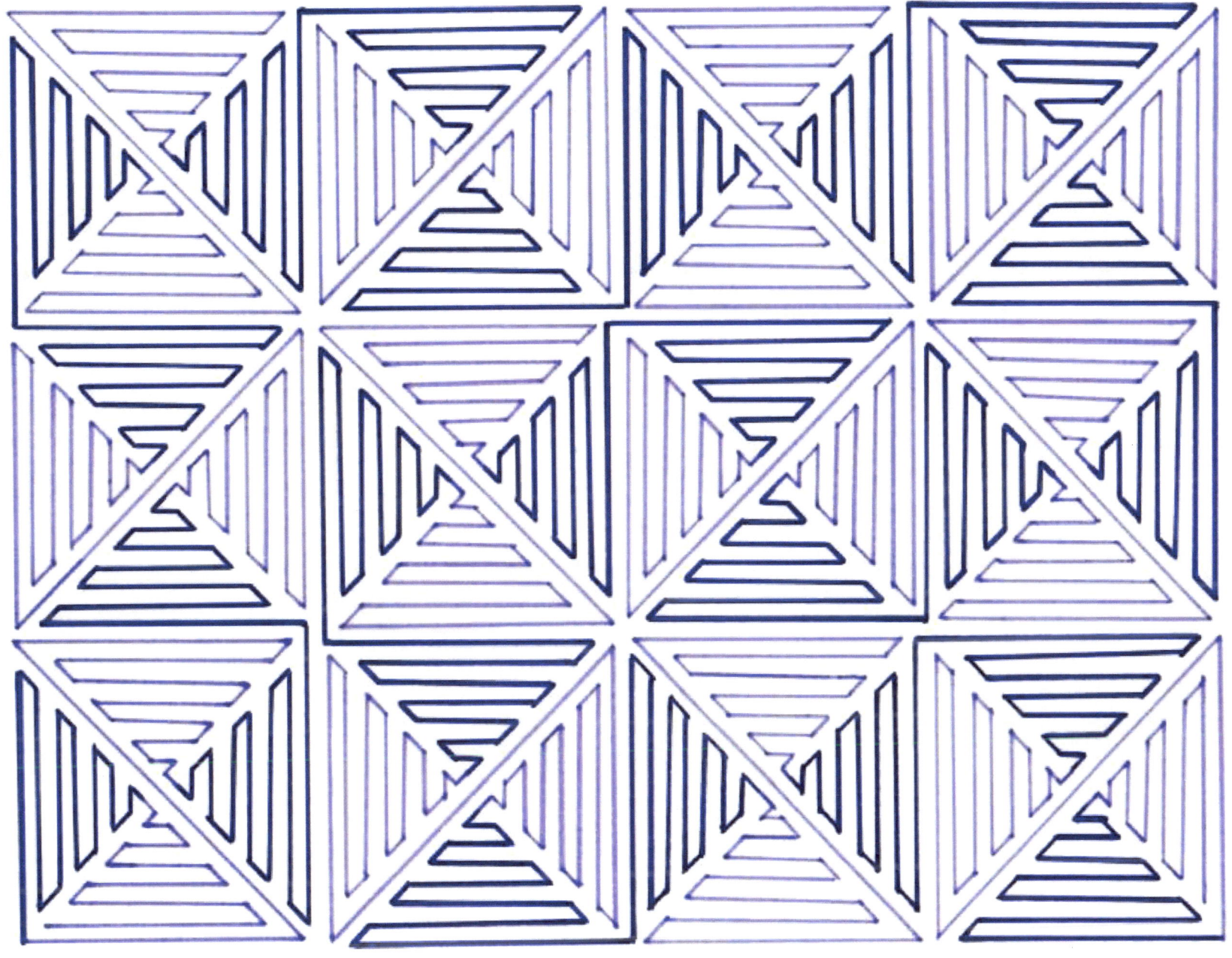

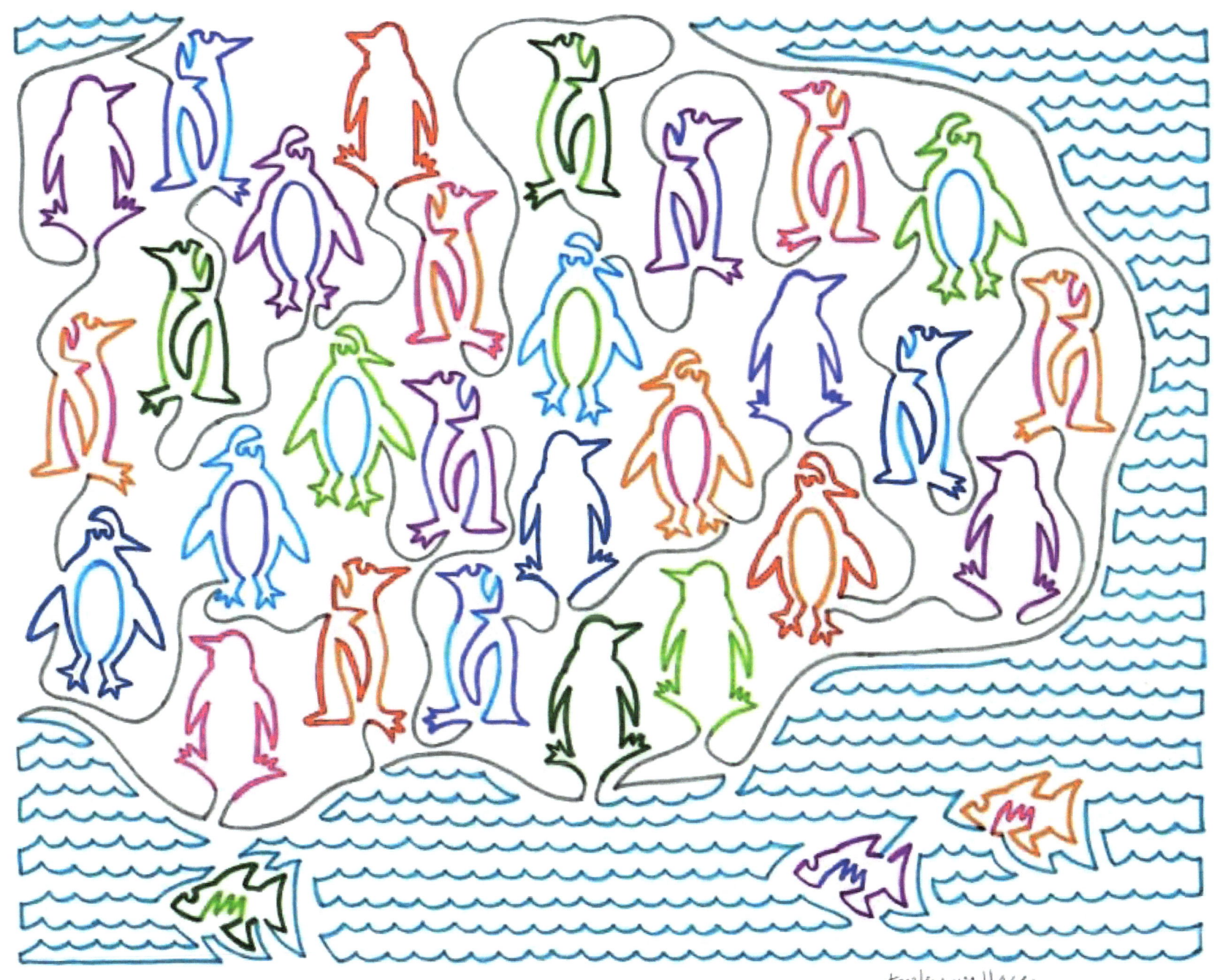

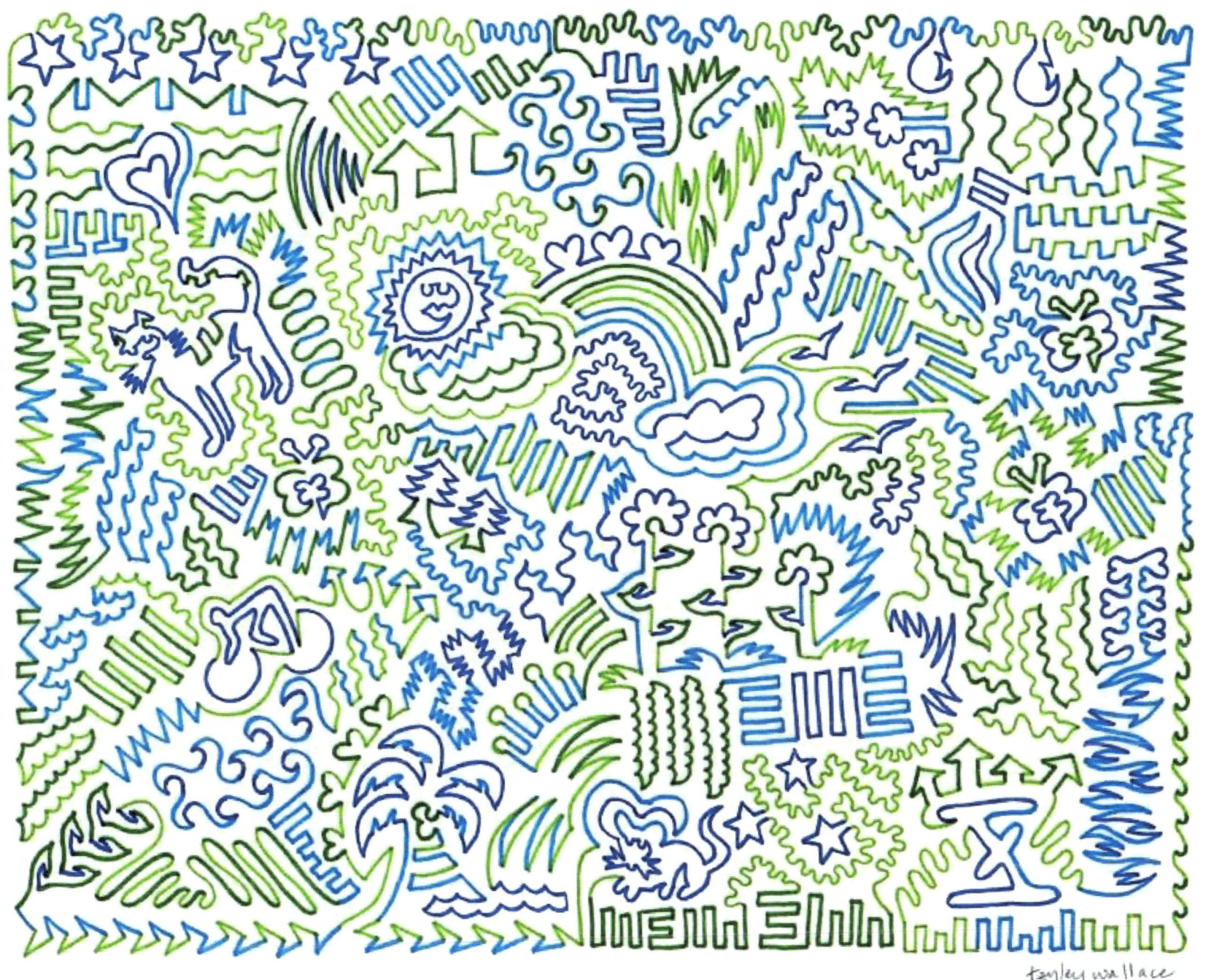

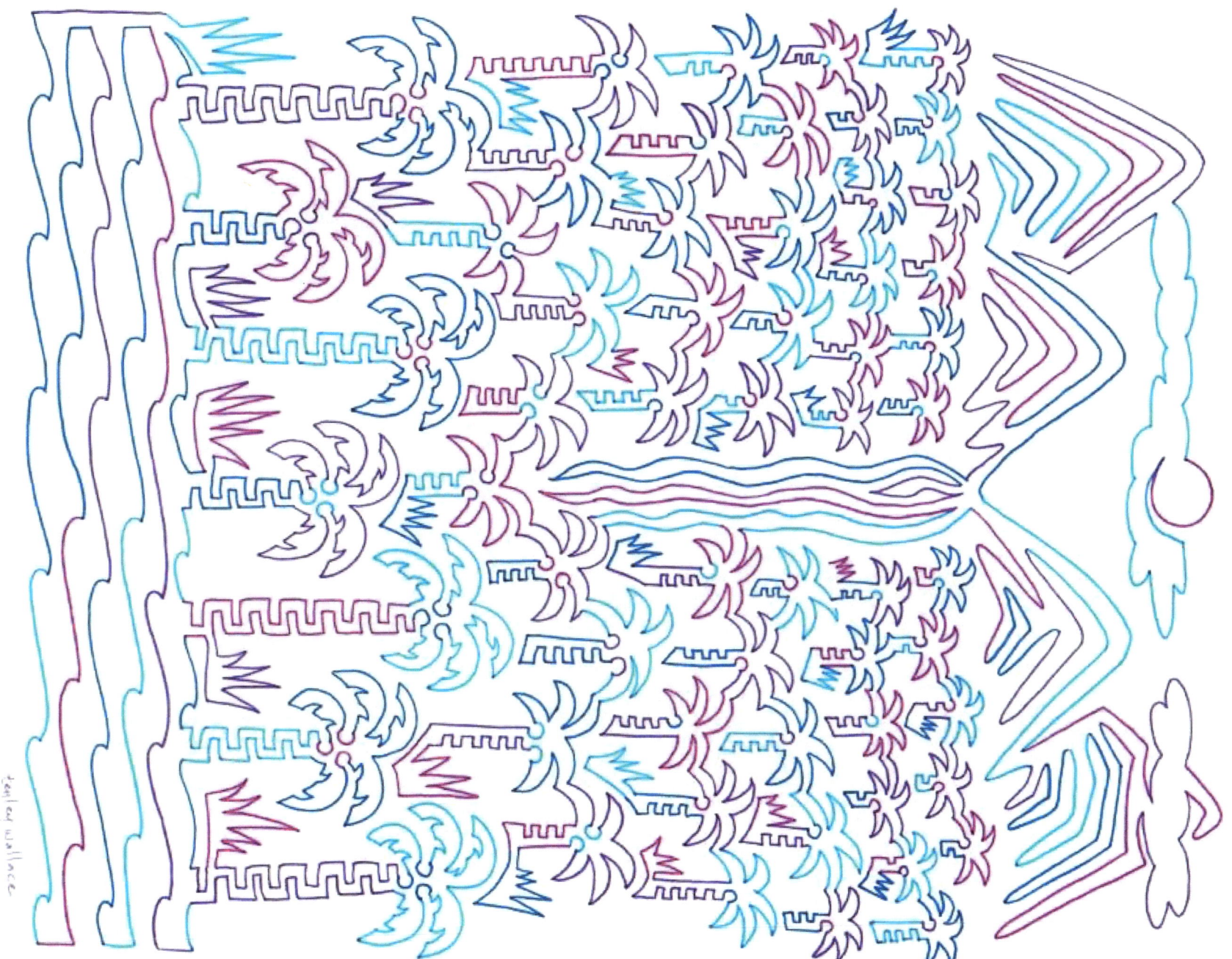

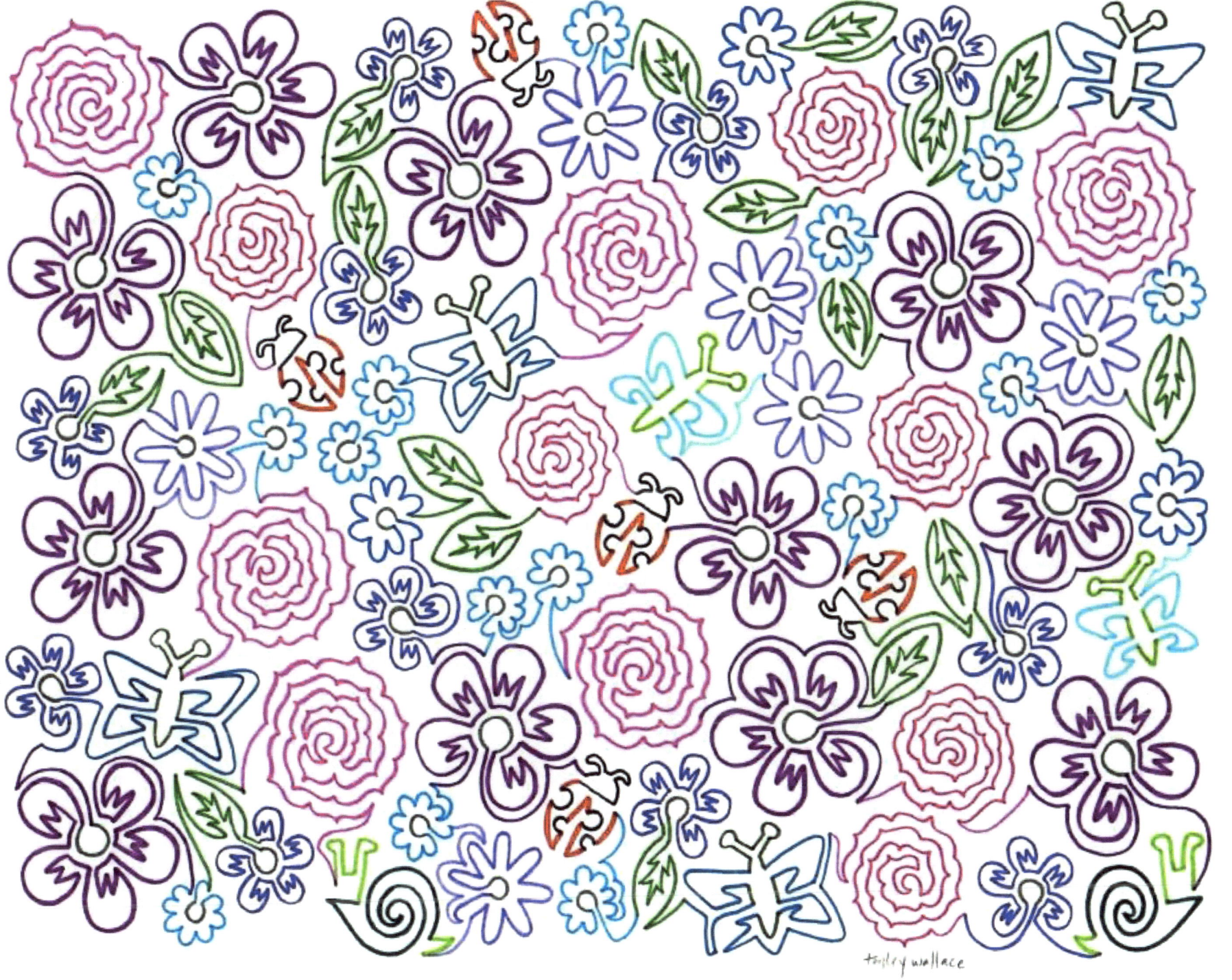

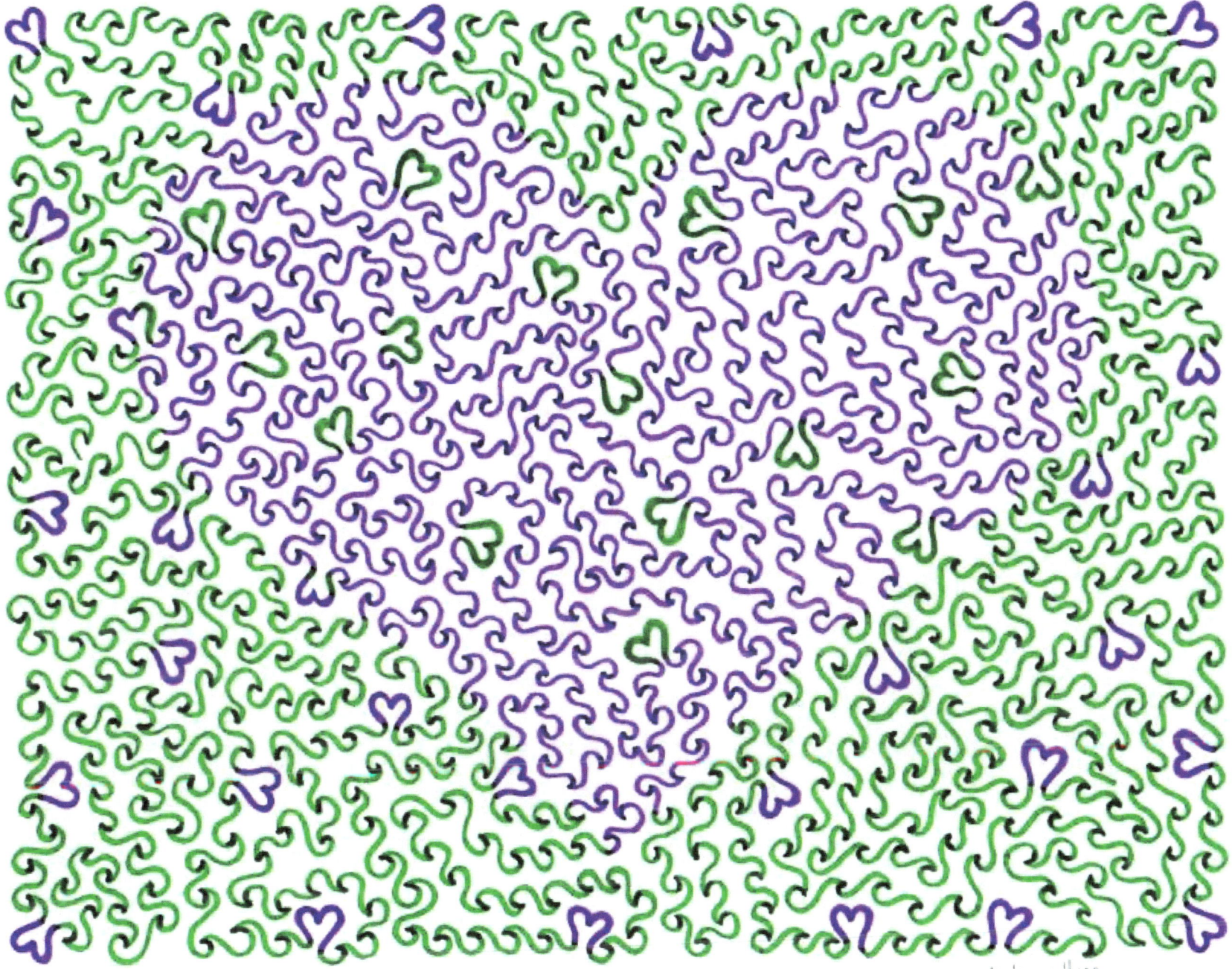

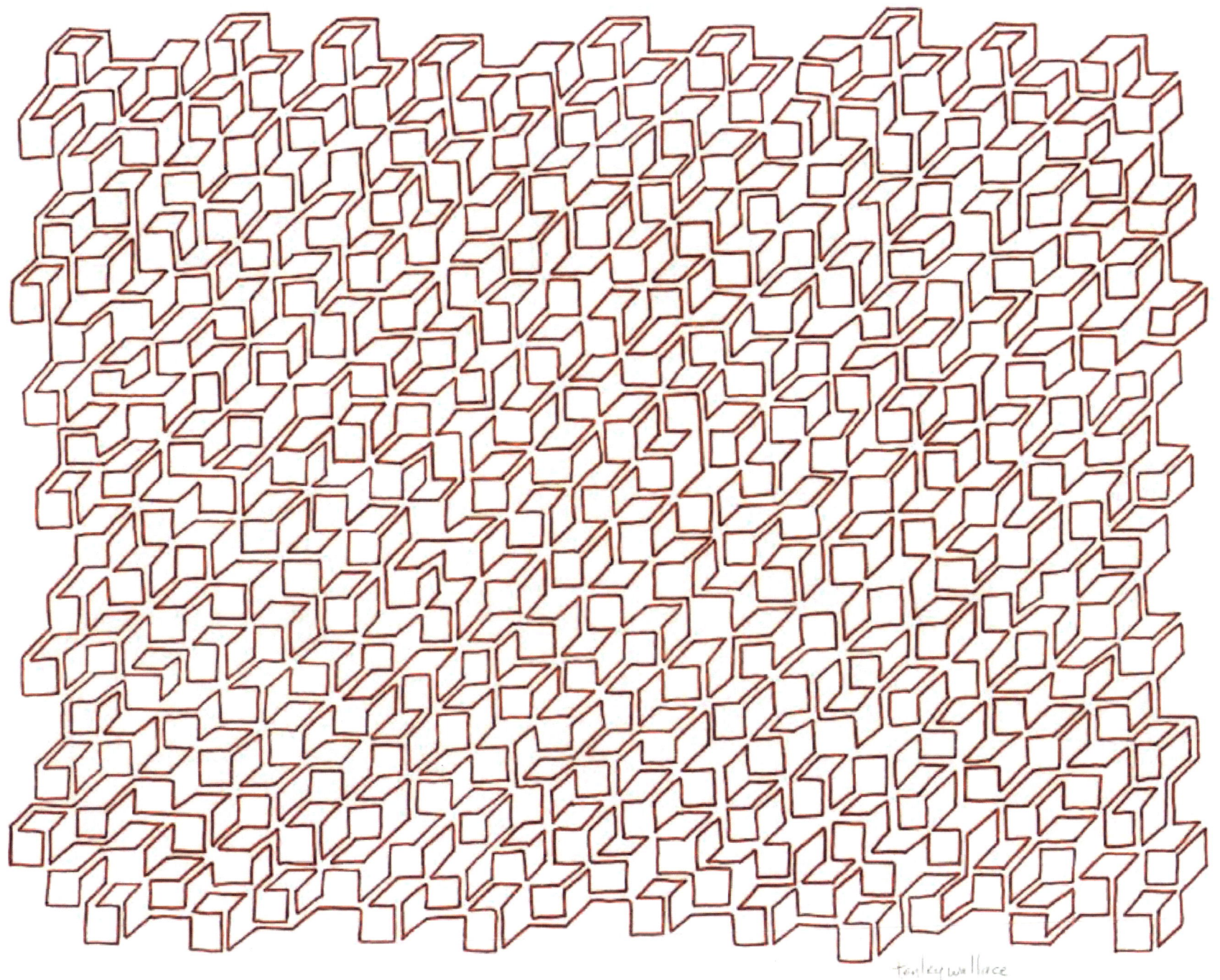

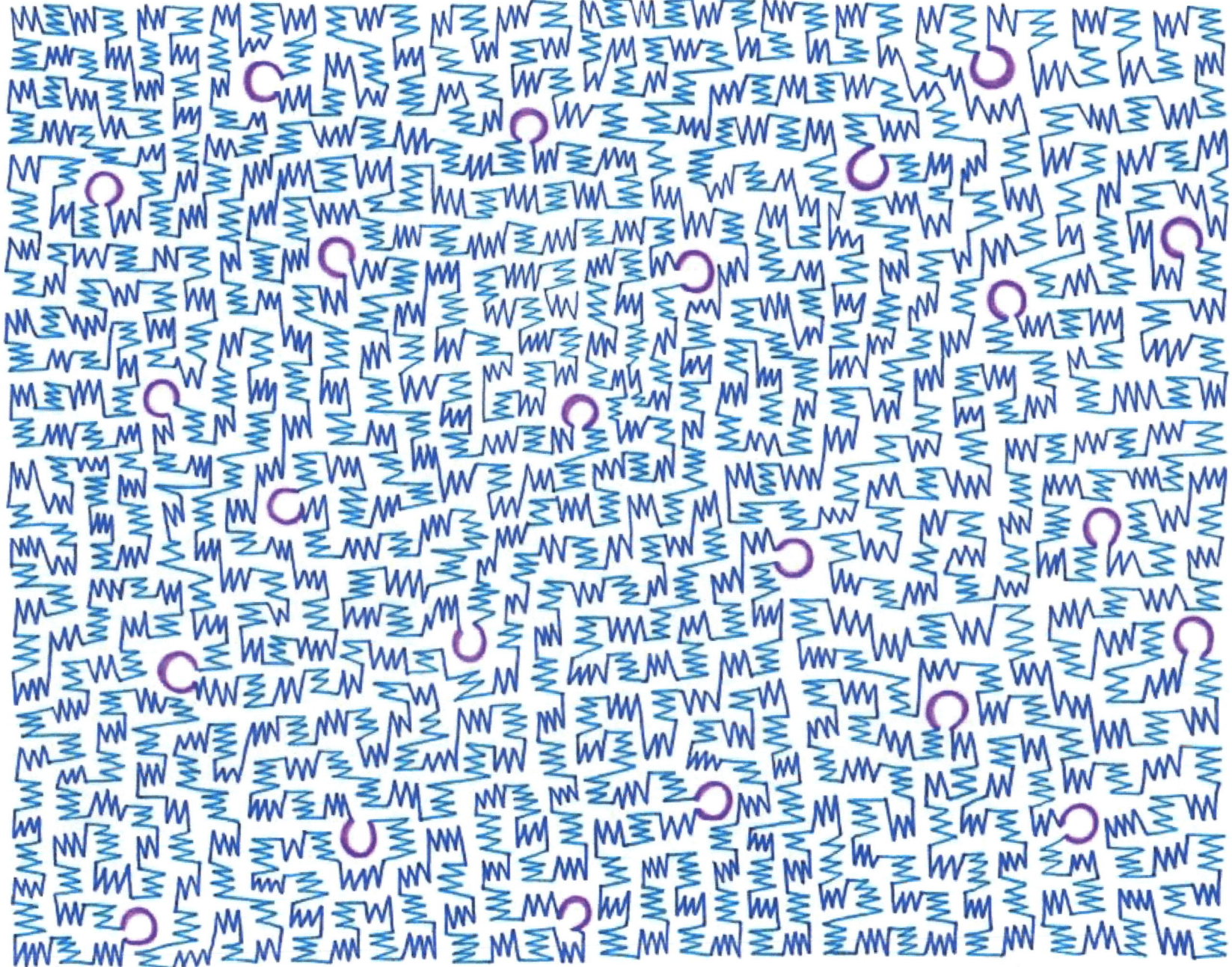

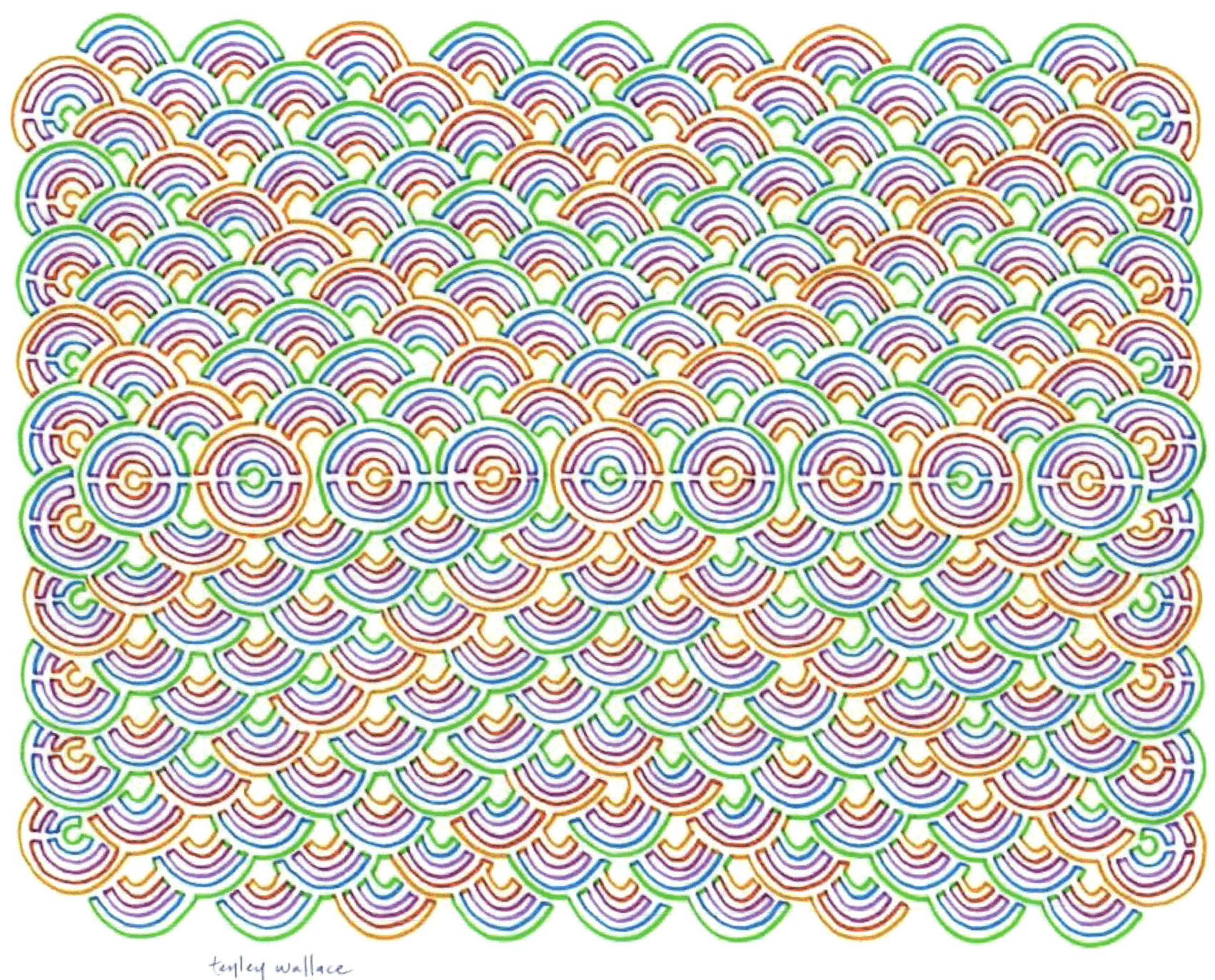

This is the end of these lines!

Thanks for looking! I hope you've enjoyed the drawings.

Take another look and you may find something new!

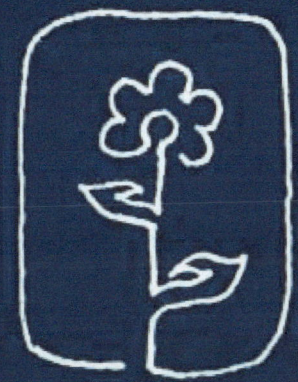

I would love to receive your feedback. Contact me, or leave a review.

 Tenley

Instagram: line_by_tenley

contact: tenleyart@gmail.com